an invitation to

DAYDREAM

an invitation to
DAYDREAM

EDITED BY
WYNN WHELDON

BARRON'S

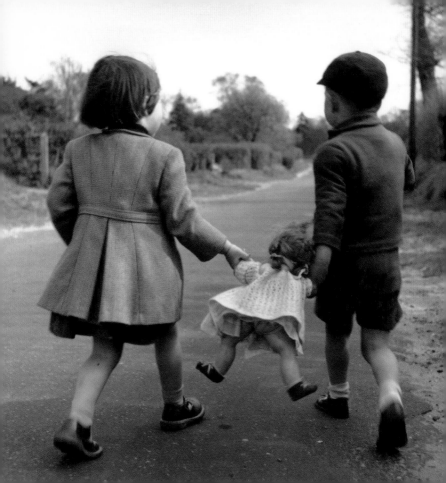

Dreams come true;
without that possibility,
nature would not incite
us to have them.

John Updike

Don't be afraid of the space between your dreams and reality. If you can dream it, you can make it so.

<div style="text-align: right">Belva Davies</div>

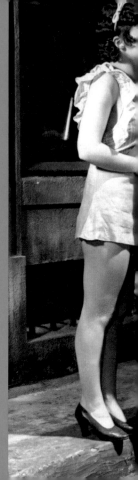

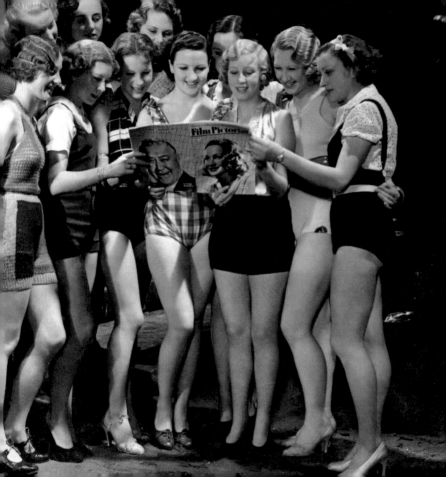

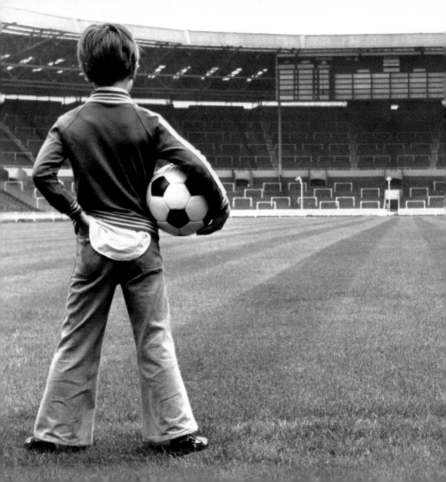

Dream lofty dreams, and as you dream, so you shall become. Your vision is the promise of what you shall one day be; your ideal is the prophecy of what you shall at last unveil.

James Lane Allen

9

And then, as if I sweetly dream'd,
I half-remember'd how it seem'd
When I, too, was a little child
About the wild woods roving wild.
Pure breezes from the far-off height
Melted the blindness from my sight,
Until, with rapture, grief, and awe,
I saw again as then I saw…

Coventry Patmore

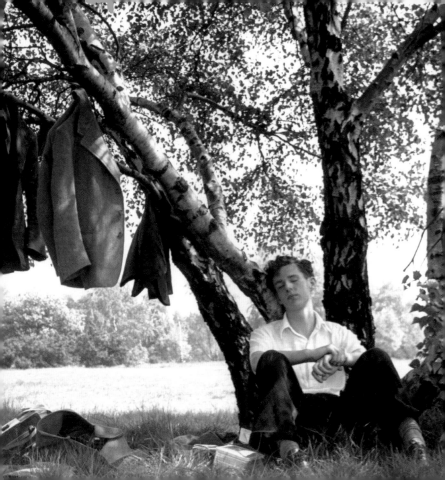

How beautiful are
thy feet with shoes,
O prince's daughter!

The Bible, Song of Solomon 7:1

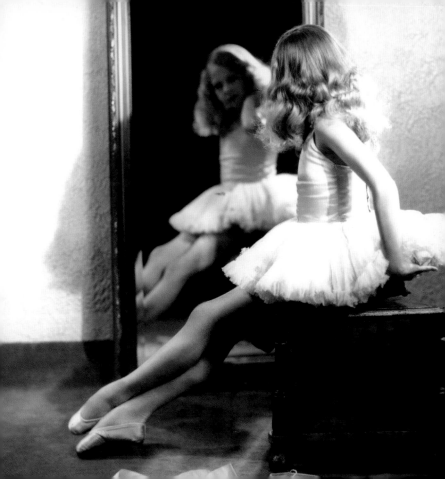

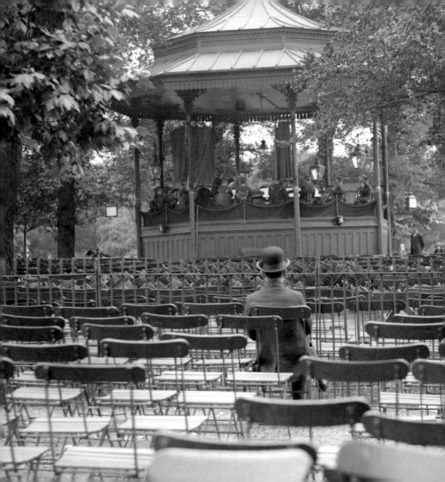

The sweetness of
her melody
Made all mine
heart in reverie.

Geoffrey Chaucer

15

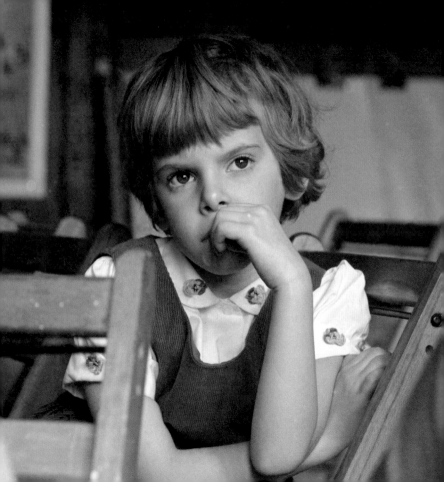

A man to be greatly good must imagine intensely and comprehensively; he must put himself in the place of another and of many others… the great instrument of moral good is the imagination.

Percy Bysshe Shelley

And the sea will grant each man new hope… his sleep brings dreams of home.

Christopher Columbus

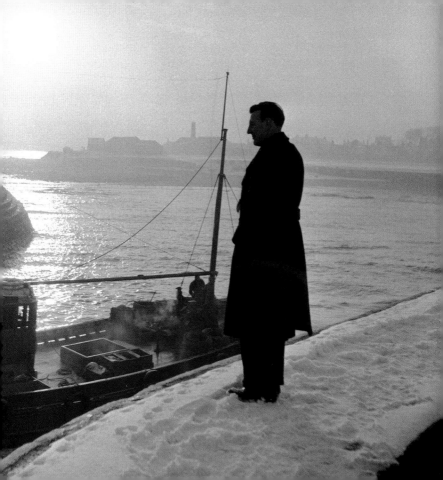

Stars shining bright above you
Night breezes seem to whisper
 "I love you"
Birds singing in the sycamore tree
Dream a little dream of me.

Gus Kahn

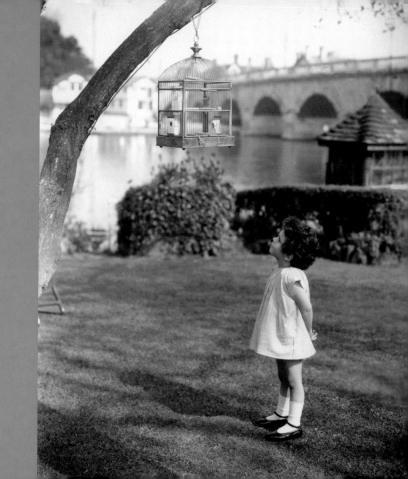

Dream manfully and nobly, and thy dreams shall be prophets.

Edward Bulwer-Lytton

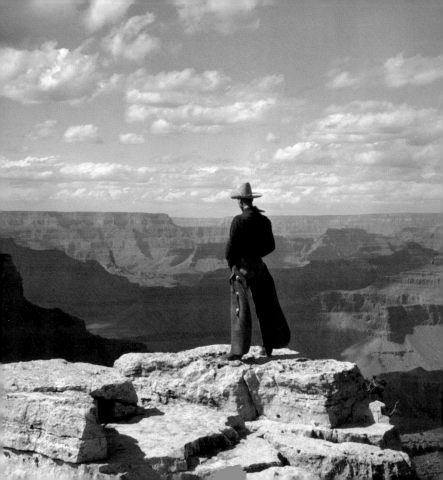

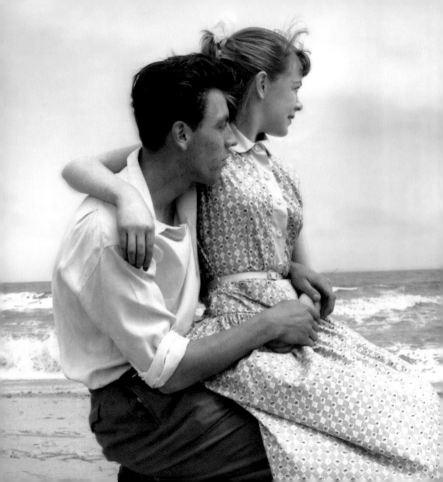

Sit in reverie and watch the changing color of the waves that break upon the idle seashore of the mind.

Henry Wadsworth Longfellow

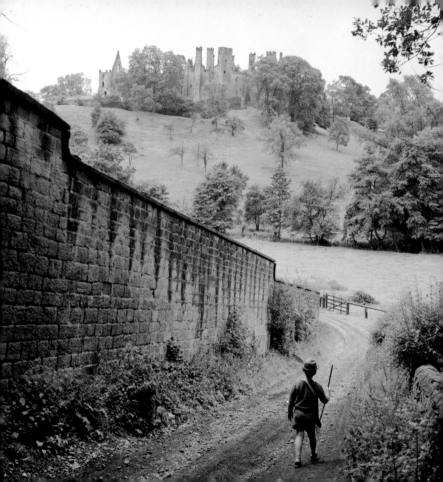

If I were Lord of Tartary,
　　Trumpeters every day
To all my meals would summon me,
　　And in my courtyards bray;
And in the evenings lamps should shine
Yellow as honey, red as wine,
While harp and flute and mandoline
　　Made music sweet and gay.

Walter de la Mare

27

Dreams—A microscope through which we look at the hidden occurrences of our soul.

Erich Fromm

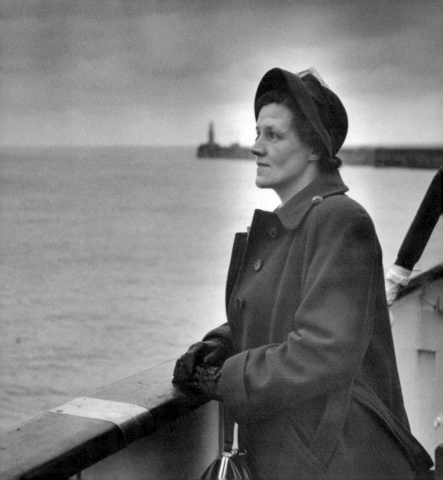

There never was
such a chap for
woolgathering.

George Eliot

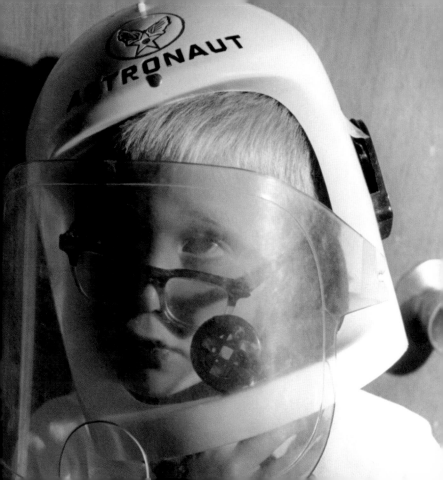

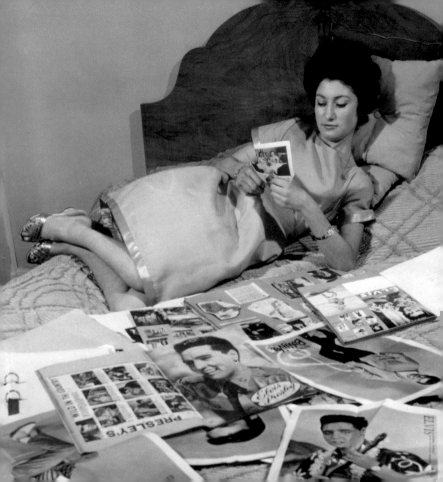

Many have no happier moments than those that they pass in solitude, abandoned to their own imagination...

Dr. Samuel Johnson

If the world were good
for nothing else, it is a
fine subject for speculation.

William Hazlitt

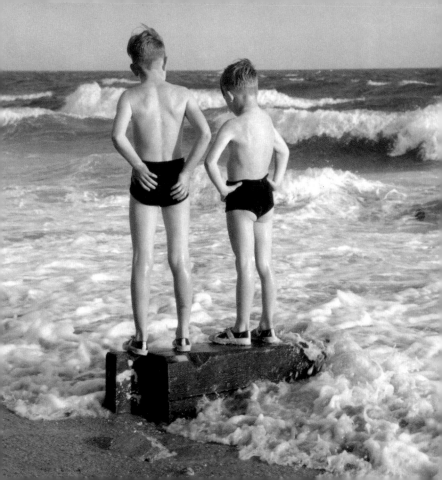

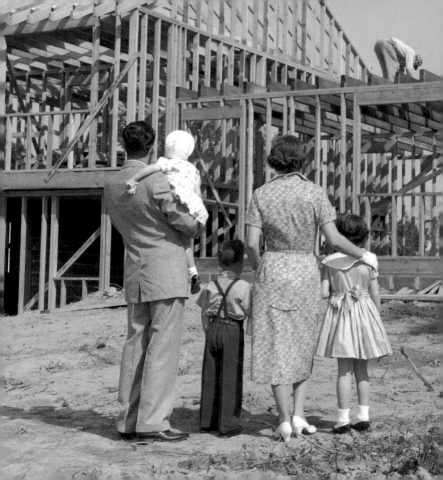

I like the dreams
of the future
better than the
history of the past.

Thomas Jefferson

Oh, it's I that am the captain
 of a tidy little ship,
Of a ship that goes a-sailing
 on the pond.

Robert Louis Stevenson

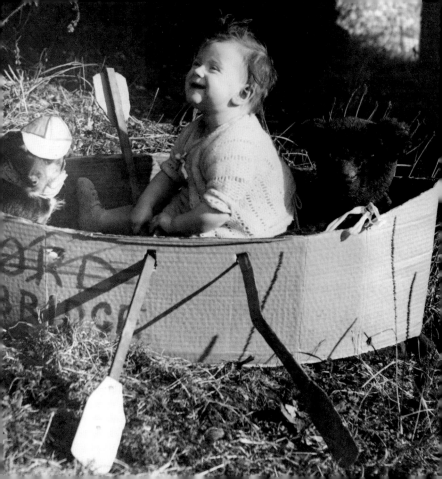

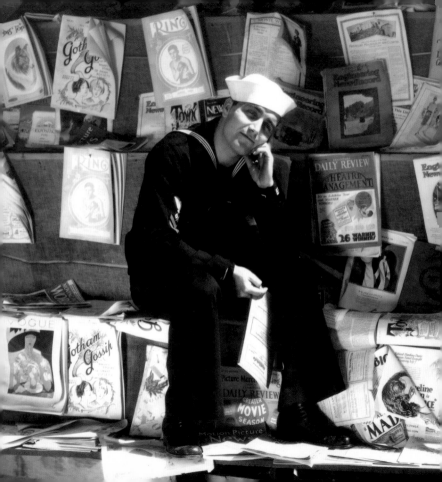

Our truest life is when
we are in dreams awake.

Henry David Thoreau

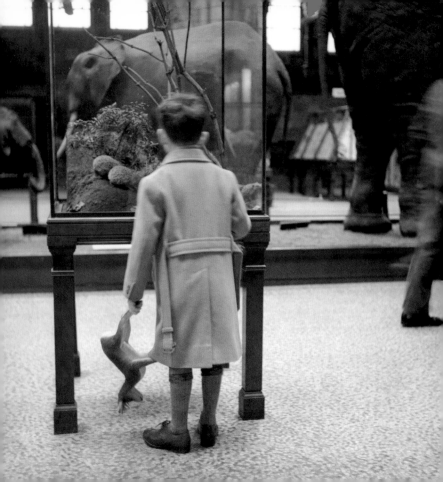

The smaller the head,
the bigger the dream.

Austin O'Malley

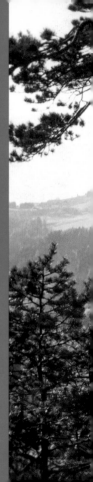

If you were to ask me why I dwell
 among green mountains,
I should laugh silently; my soul is
 serene.
The peach blossom follows the
 moving water;
There is another heaven and earth
 beyond the world of men.

Li Po

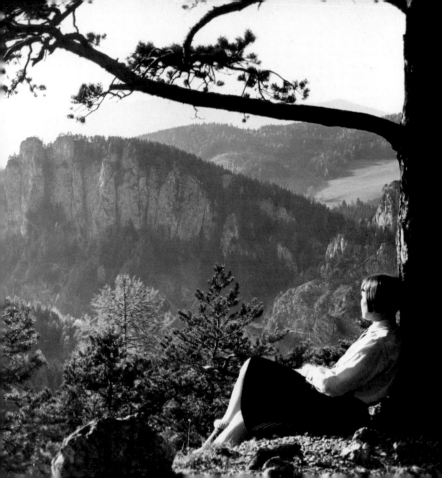

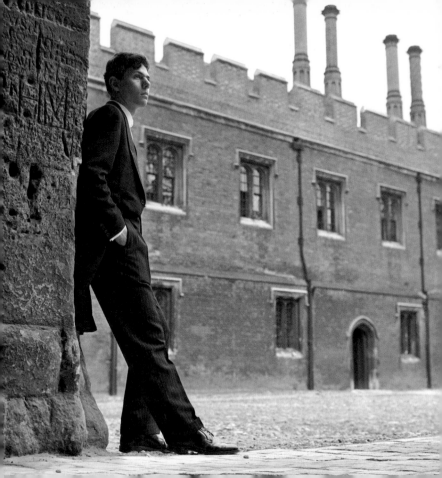

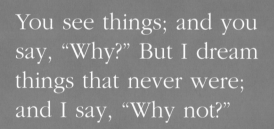

You see things; and you
say, "Why?" But I dream
things that never were;
and I say, "Why not?"

Bernard Shaw

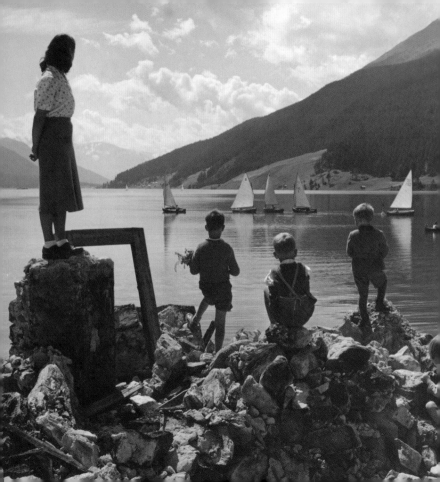

We are such stuff
As dreams are made on; and our little life
Is rounded with a sleep.

William Shakespeare

Living in dreams of
yesterday, we find ourselves
still dreaming of impossible
future conquests.

Charles Lindbergh

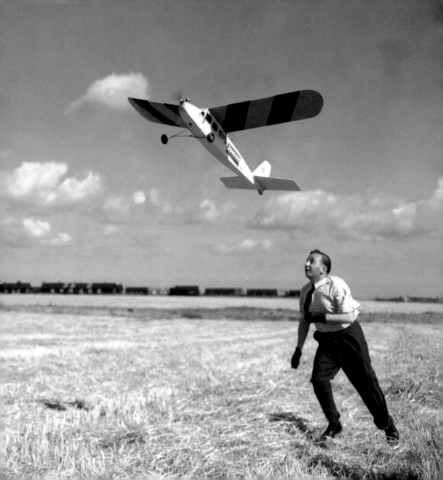

When a dream is born in you
 With a sudden clamorous pain,
When you know the dream is true
 And lovely, with no flaw nor stain,
O then, be careful, or with sudden clutch
You'll hurt the delicate thing you love so much.

Robert Graves

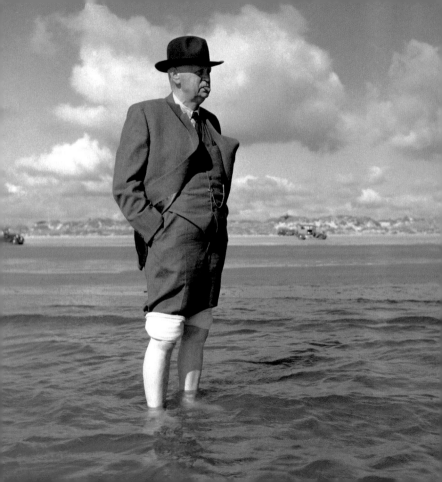

I have learned, that if one advances confidently in the direction of his dreams, and endeavors to live the life he has imagined, he will meet with a success unexpected in common hours.

Henry David Thoreau

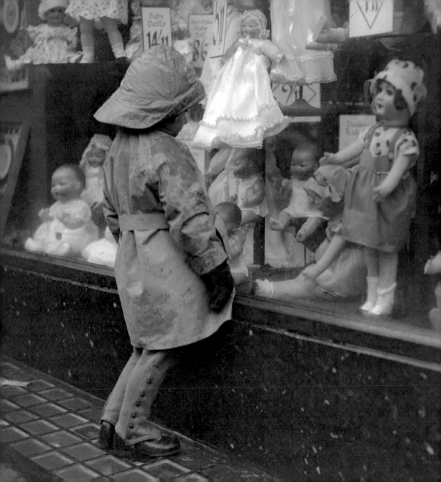

If there were dreams to sell,
Merry and sad to tell,
And the crier rung his bell,
What would you buy?

Thomas Lovell Beddoes

I dreamt I was in love again
 With the One Before the Last,
And smiled to greet the pleasant pain
 Of that innocent young past.

Rupert Brooke

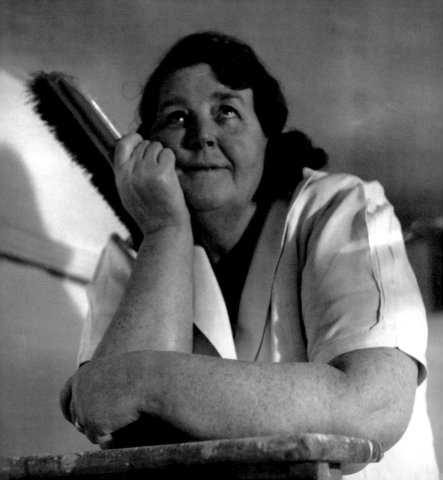

This young day dreamer built castles in the air for himself.

William Makepeace Thackeray

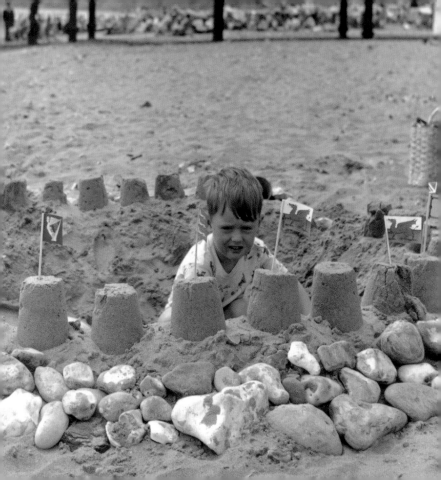

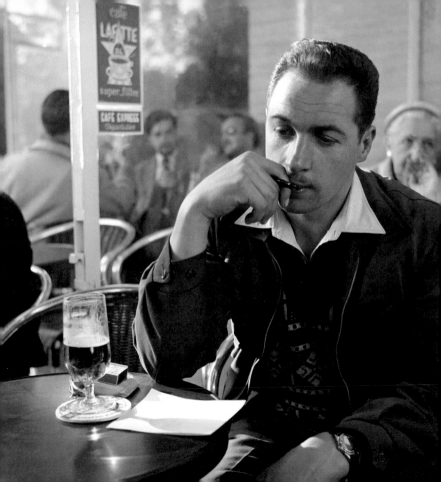

Biting my truant pen, beating
 myself for spite,
"Fool," said my Muse to me,
 "look in thy heart and write".

<div align="right">Sir Philip Sydney</div>

Very, very early in my childhood I had acquired the habit of going about alone to amuse myself in my own way.

William Henry Hudson

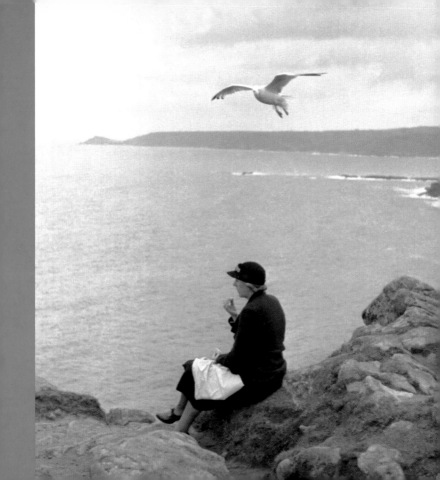

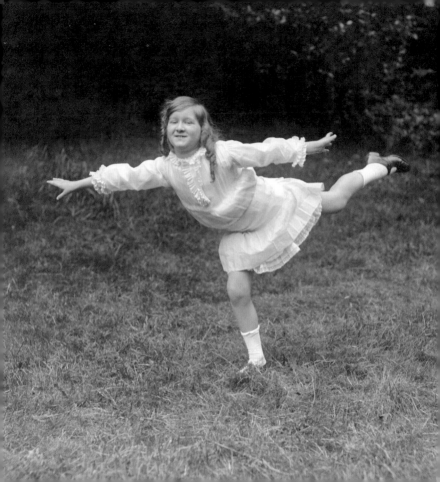

Hold fast to dreams,
For if dreams die
Life is a broken-winged bird,
That cannot fly.

Langston Hughes

Was it a vision, or a
waking dream?
Fled is that music: —
do I wake or sleep?

John Keats

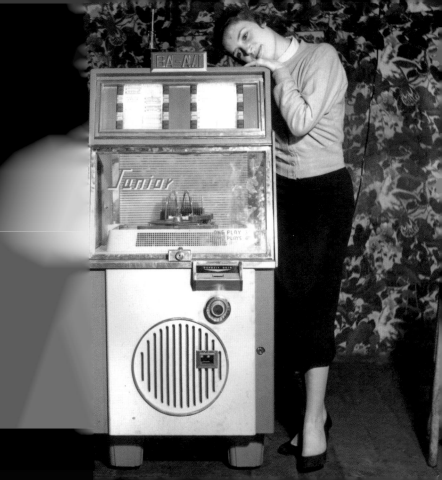

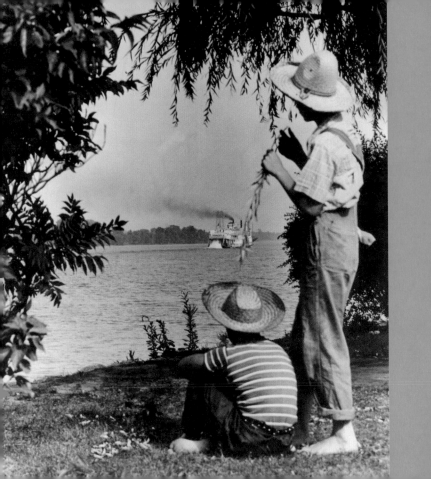

Like dreams,
small creeks
grow into
mighty rivers.

Source Unknown

Your old men
shall dream
dreams, your
young men shall
see visions.

The Bible, Joel 2:28

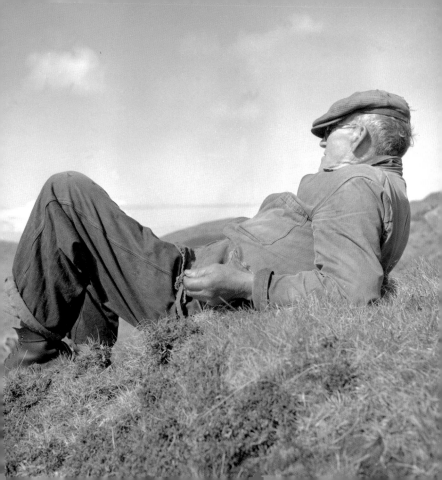

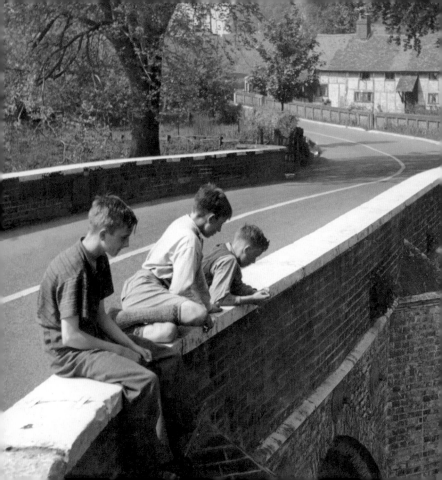

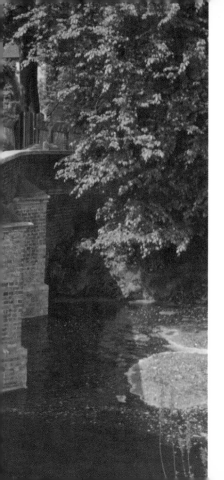

Ah, great it is to
 believe the dream
As we stand in youth
 by the starry stream;
But a greater thing is
 to fight life through,
And say at the end,
 "The dream is true!"

Edwin Markham

Imagination and fiction
make up more than three
quarters of our real life.

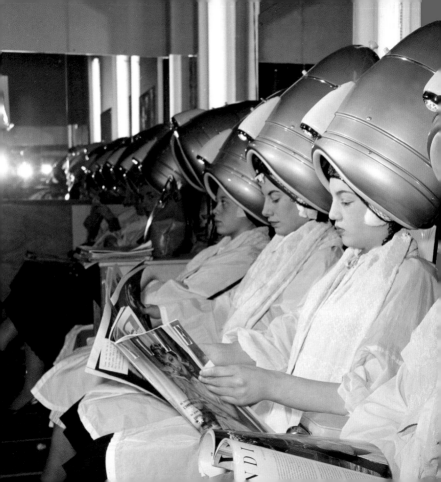

Throw your dreams
into space like a
kite, and you do
not know what it
will bring back, a
new life, a new
friend, a new love,
a new country.

Anais Nin

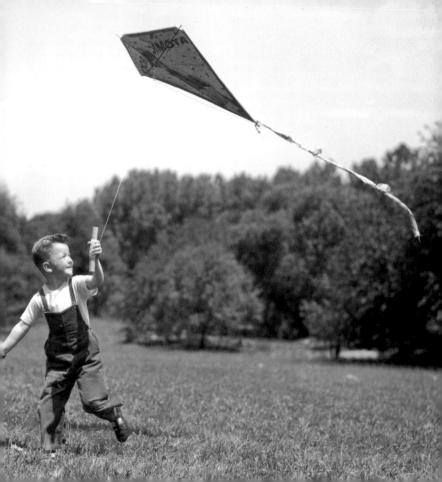

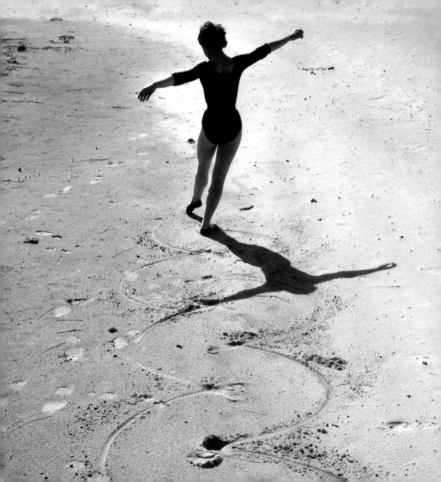

Tell me, tell me, smiling child,
What the past is like to thee?
"An Autumn evening, soft and mild,
With a wind that sighs mournfully"
Tell me, what is the present hour?
"A green and flowery spray,
Where a young bird sits gathering its power
To mount and fly away".
And what is the future, happy one?
"A sea beneath a cloudless sun;
A mighty, glorious, dazzling sea
Stretching into infinity."

Emily Brontë

Dreaming of a peak whose height
 Will show me every hill,
A single mountain on whose side
 Life blooms for ever and is still.

Edwin Muir

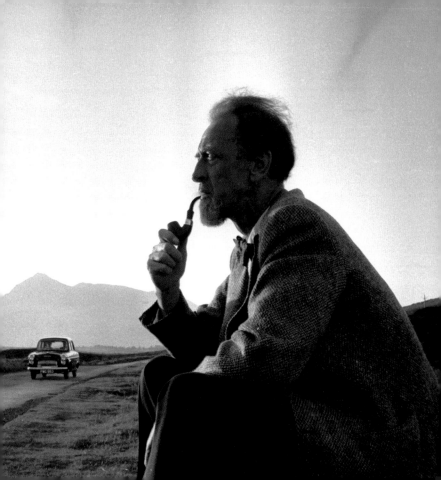

I prefer to be a dreamer among the humblest, with visions to be realized, than lord among those without dreams and desires.

Kahlil Gibran

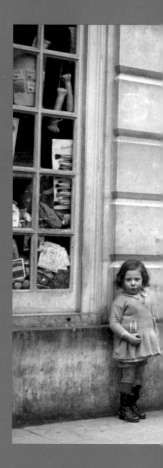

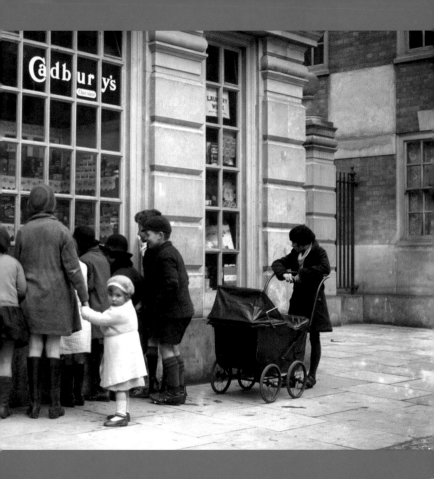

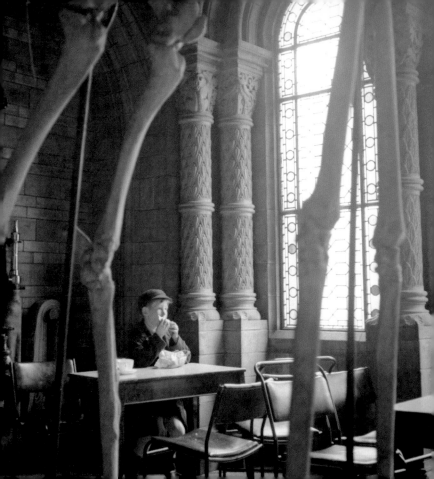

My reverie has been so deep, that I have scarce had an interval to think myself uneasy.

Alexander Pope

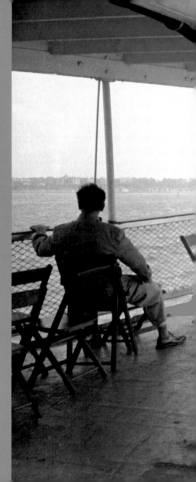

In my reverie,
methought I saw
the continent of
Europe... far away.

Charlotte Brontë

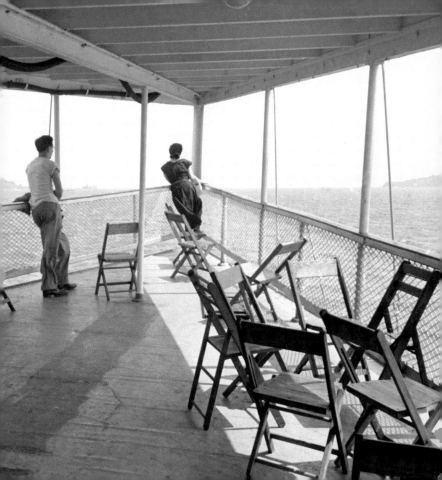

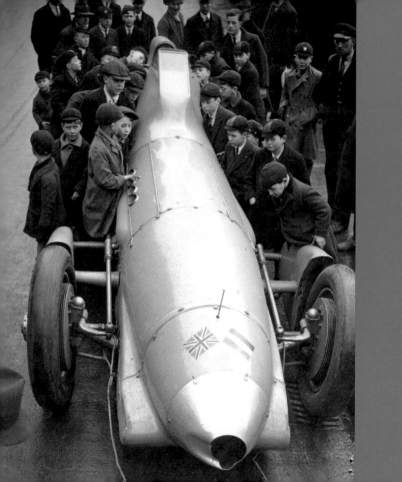

I lived a dream life (almost too exclusively, perhaps) when I was a lad and even now my thought goes back for refreshment to those days when all the world seemed to be a place of heroic adventure in which one's heart must keep its own counsel.

Woodrow Wilson

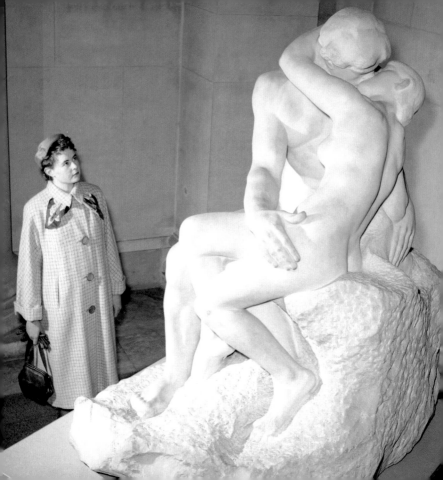

Within your heart
Keep one still, secret spot
Where dreams may go.

Louise Driscoll

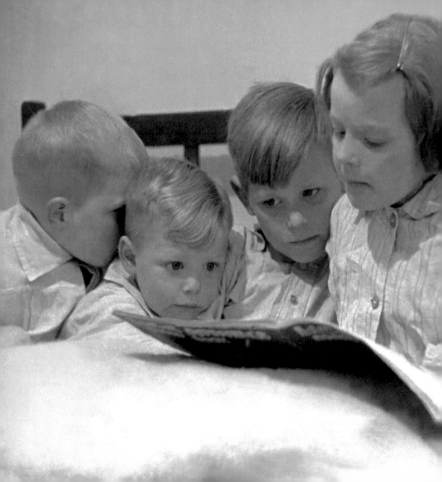

How many miles to Babylon?
 Threescore miles and ten.
Can I get there by candle-light?
 Yes, and back again.
If your heels are nimble and light,
 You may get there by candle-light.

Anonymous

95

See sunrise and sunset,
and nothing but dreams between.

John Ruskin

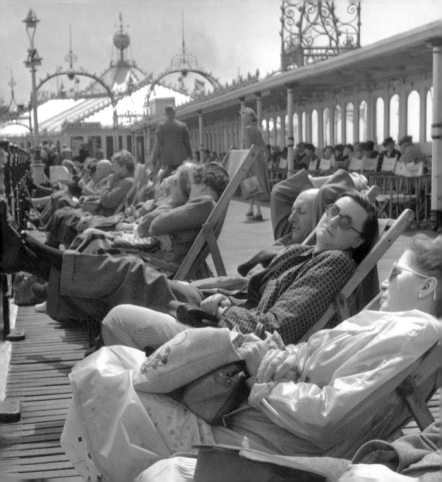

The future belongs to
those who believe in the
beauty of their dreams.

Eleanor Roosevelt

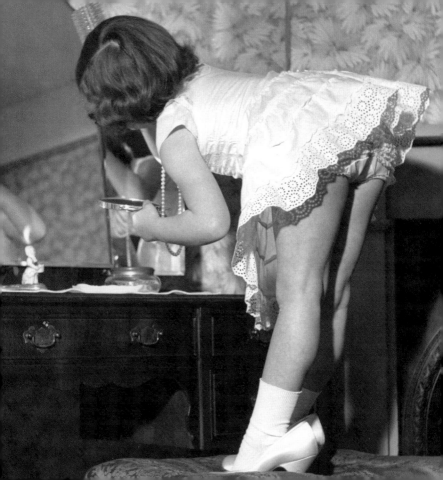

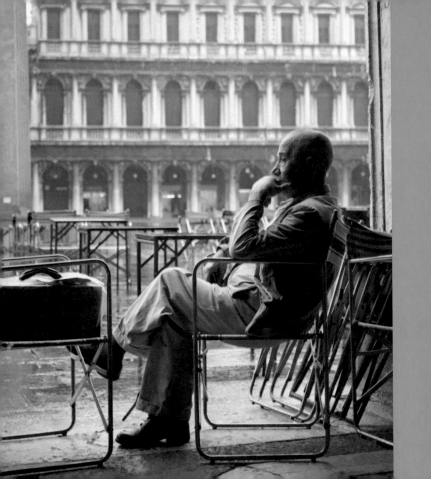

Don't let anybody tell you you're wasting your time when you're gazing into space. There is no other way to conceive an imaginary world. I never sit down in front of a bare page to invent something. I daydream about my characters, their lives and their struggles, and when a scene has been played out in my imagination and I think I know what my characters felt, said and did, I take pen and paper and try to report what I've witnessed.

Stephen Vizinczey

What a day for a
 day dream,
What a day for a
 day dreamin' boy.

John Sebastian

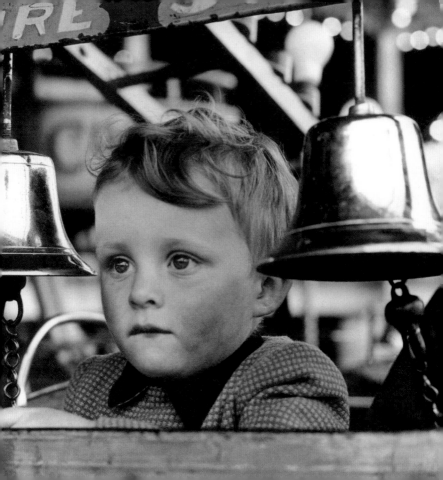

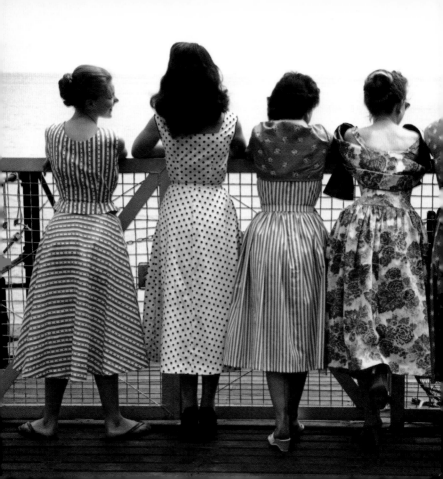

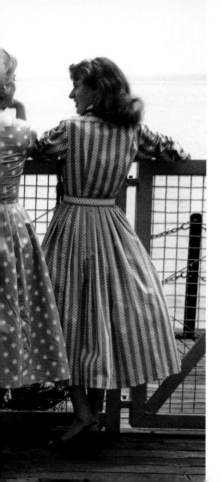

Tomorrow's travel will carry you, body and mind, into some different parish of the infinite.

Robert Louis Stevenson

When once you have
tasted flight, you will
forever walk the earth
with your eyes turned
skyward, for there you
have been, and there
you long to return.

Leonardo da Vinci

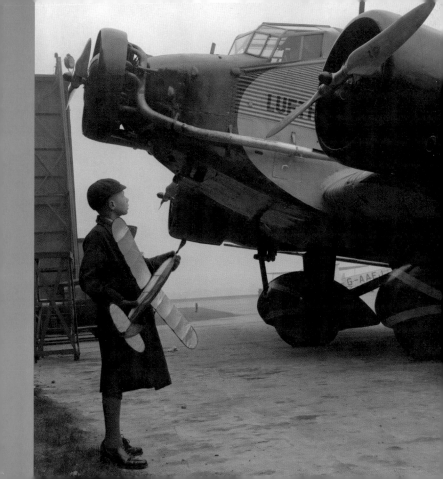

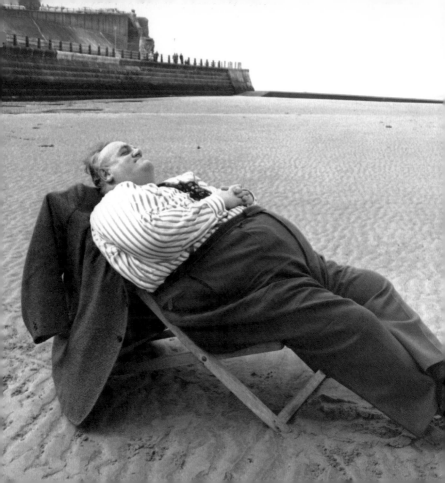

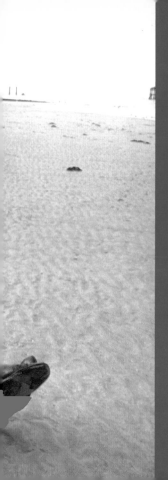

Once upon a time,
I dreamt
I was a butterfly… Suddenly
I awoke… Now, I do not
know whether I was then
a man dreaming I was
a butterfly, or whether I
am now a butterfly dreaming
that I am a man.

Chuang-Tzu

Picture Credits

p.4: Love's Young Dream, 1955. p.7: Evergreen, circa 1934. p.8: Wembley Tour, 1977. p.11: Wimbledon Rest, 1957. p.13: Young Ballerina, 1935. p.14: Audience Of One, circa 1926. p.16: Experimental Children, 1961. p.19: Boats Coming In, 1955. p.21: Looking At Birdcage, circa 1925. p.23: Lone Ranger, 1935, © Archive Photos. p.24: Young Couple, 1955. p.26: Sheerwood Walk, circa 1955. p.29: Trip To France, 1951. p.31: Astronaut's Helmet, circa 1965. p.32: Dreaming, 1962. p.35: Young Canutes, circa 1950. p.36: Dream Home, circa 1955, © Lambert/Archive Photos. p.39: Boat Race Fan, circa 1935. p.40: The Fleet's In, 1928. p.42: They're More My Size, 1953. p.45: Polleroswand, 1931. p.46: Eton Schoolboy, 1965. p.48: Watching The Boats, circa 1950. p.51: North By Northwest, 1954. p.52: Bike Dreams, circa 1935, © American Stock/Archive Photos. p.54: Bathing Suit, 1955. p.56: Little Girl's Dream, 1934. p.59: Spring Cleaning, 1952. p.61: Sandcastles, 1956. p.62: Missing You, 1956. p.65: Peaceful Lunch, 1938. p.66: Young Ballerina, 1916. p.69: Dream On, 1957. p.70: Mississippi Dreaming, 1964. p.73: Life On An Island, 1958. p.74: River Gade, 1945. p.77: Haircare, 1956. p.79: Kite Flying, circa 1955, © Lambert/Archive Photos. p.80: Beach Ballet, 1955. p.83: Solitary Pipe, 1956. p.85: Sweet Dreams, 1933. p.86: Food For Thought, 1953. p.89: Land Ahoy, circa 1950. p.90: Schoolboys' Dream, circa 1929. p.92: The Kiss, 1955. p.94: Bedtime Stories, 1945. p.97: On Brighton Pier, 1952. p.99: Dressing Up, 1958. p.100: Out Of Season, 1958. p.103: When I'm Grown Up, 1946. p.104: Eastbourne Pier, 1956. p.107: Planespotter, 1934. p.108: Cyril Sunbathes, 1979.

Text Credits

AN INVITATION TO DAYDREAM:

First English edition for North America
published by Barron's Educational Series, Inc., 2003.

First published by MQ Publications Limited
12 The Ivories, 6-8 Northampton Street, London, England

Copyright © MQ Publications Limited 2002

Design: Bet Ayer
Series Editor: Tracy Hopkins

All inquiries should be addressed to:
Barron's Educational Series, Inc.
250 Wireless Boulevard
Hauppauge, New York 11788
http://www.barronseduc.com

International Standard Book No. 0-7641-5634-9

Library of Congress Catalog Card No. 2002110108

Printed and bound in China

9 8 7 6 5 4 3 2 1

Cover image © Archive Photos

1. ⚲